CAT ANATOMY COLORING BOOK

SCAN THE CODE TO ACCESS YOUR FREE DIGITAL COPY

THIS BOOK BELONGS TO

TABLE OF CONTENTS

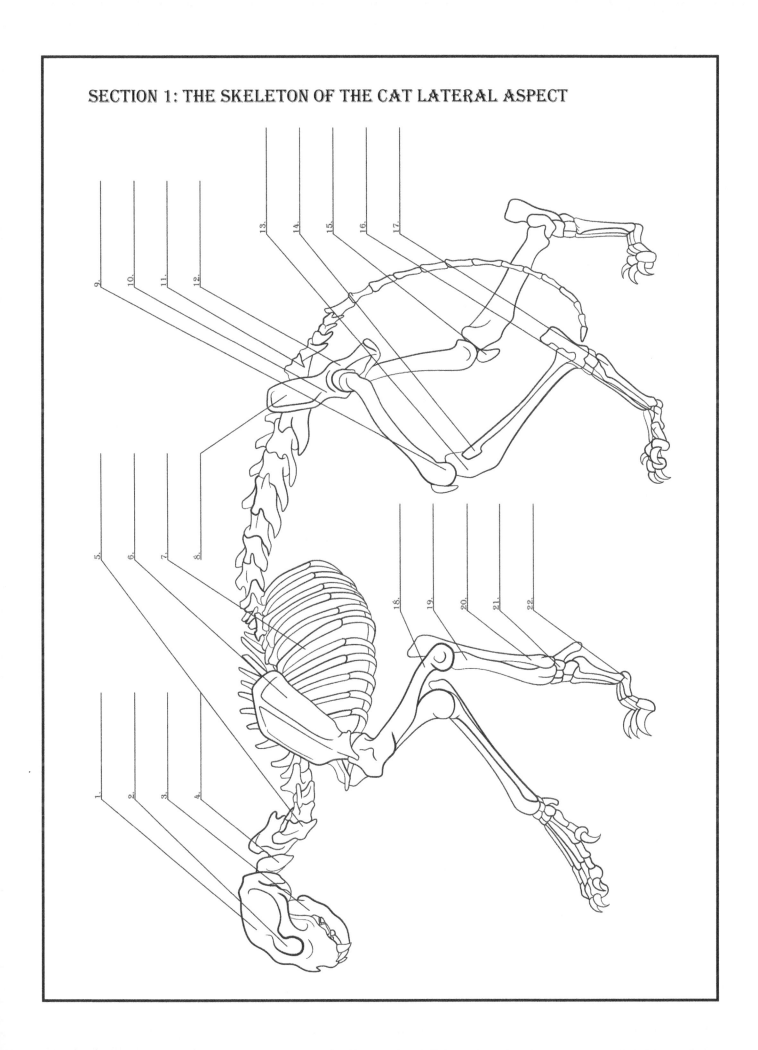

SECTION 1: THE SKELETON OF THE CAT LATERAL ASPECT

1. SKULL
2. ORBIT
3. MANDIBLE
4. ATLAS
5. AXIS
6. SCAPULA
7. RIB
8. ILIUM
9. FEMUR
10. PUBIS
11. SACRUM
12. ISCHIUM
13. TIBIA
14. FIBULA
15. PATELLA
16. PHALANGES
17. METATARSUS
18. HUMERUS
19. RADIUS
20. ULNA
21. CARPUS
22. METACARPUS

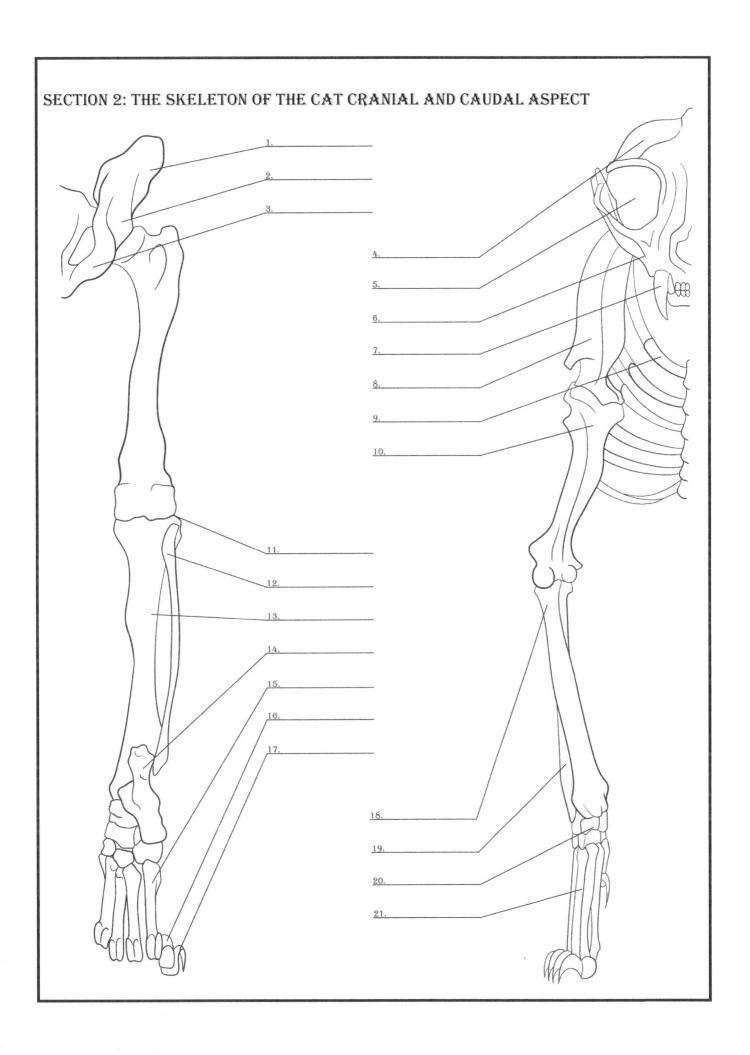

1. _____

2. _____

3. _____

4. _____

5. _____

6. _____

7. _____

8. _____

9. _____

10. _____

11. _____

12. _____

13. _____

14. _____

15. _____

16. _____

17. _____

18. _____

19. _____

20. _____

21. _____

SECTION 2: THE SKELETON OF THE CAT CRANIAL AND CAUDAL ASPECT

1. HIPBONE
2. HIP JOINT
3. ISCHIATIC TUBERCLE
4. SKULL
5. ORBIT
6. MANDIBLE
7. CANINE TOOTH
8. SCAPULA
9. RIB
10. HUMERUS
11. STIFLE JOINT
12. FIBULA
13. TIBIA
14. CALCANEAN BONE
15. METATARSAL BONE
16. PHALANGEAL BONE
17. CLAW BONE

SECTION 3: THE SKELETON OF THE CAT DORSAL ASPECT

1. _____
2. _____
3. _____
4. _____
5. _____
6. _____
7. _____
8. _____
9. _____
10. _____

SECTION 3: THE SKELETON OF THE CAT DORSAL ASPECT

1. ORBIT
2. SKULL
3. ATLAS
4. AXIS
5. SCAPULA
6. HUMERUS
7. RIB
8. SACRUM
9. ILIUM
10. ISCHIUM

SECTION 4: THE MUSCLES OF THE CAT LATERAL ASPECT

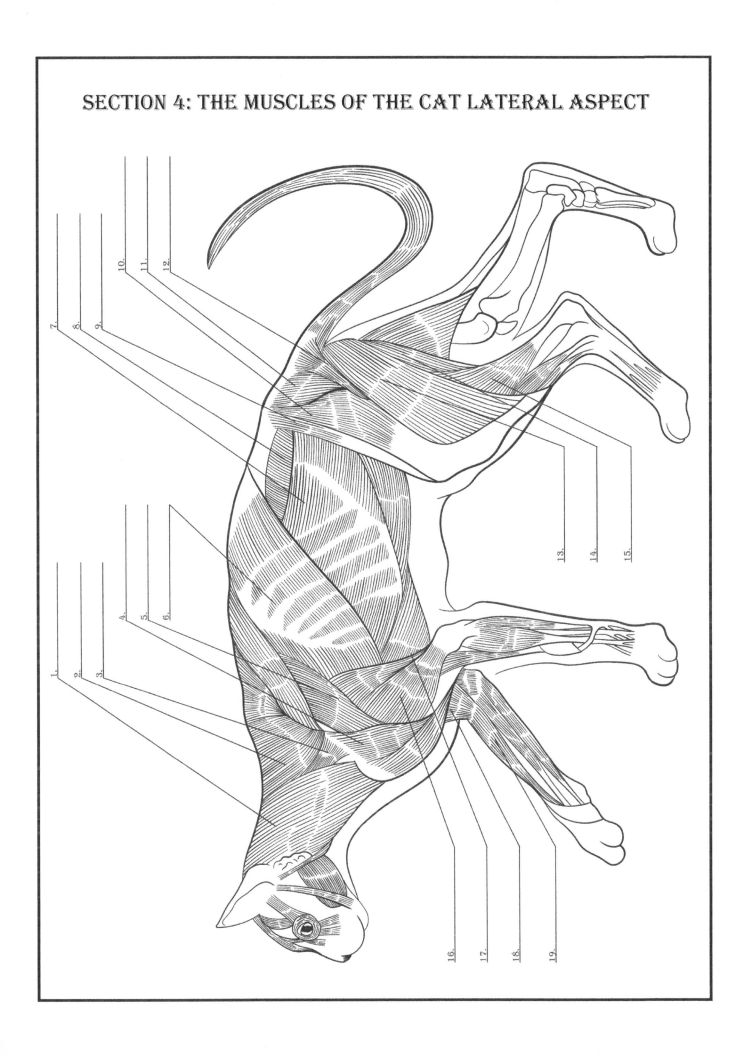

SECTION 4: THE MUSCLES OF THE CAT LATERAL ASPECT

1. BRAHIOCEPHALICUS MUSCLE
2. TRAPEZIUS MUSCLE
3. OMOSTRANSVERSARIUS MUSCLE
4. DELTOIDEUS MUSCLE
5. INFRASPINATUSM MUSCLE
6. LATISSIMUS DORSI MUSCLE
7. EXTERNAL OBLIQUE ABDOMINAL MUSCLE
8. INTERNAL OBLIQUE ABDOMINAL MUSCLE
9. SARTORIUS MUSCLE
10. TENSOR FASCIAE LATAE MUSCLE
11. CAUDOFEMORALIS MUSCLE
12. SERRATUS VENTRALIS MUSCLE
13. BICEPS FEMORIS MUSCLE
14. SEMITENDINOSUS MUSCLE
15. GASTROCNEMICUS MUSCLE
16. TRICEPS BRACHII MUSCLE
17. PECTORALIS PROFUNDUS MUSCLE
18. PECTORALIS DESCENDENS MUSCLE
19. EXTENSOR CARPI RADIALIS

SECTION 5: THE MUSCLES OF THE CAT CRANIAL AND CAUDAL ASPECT

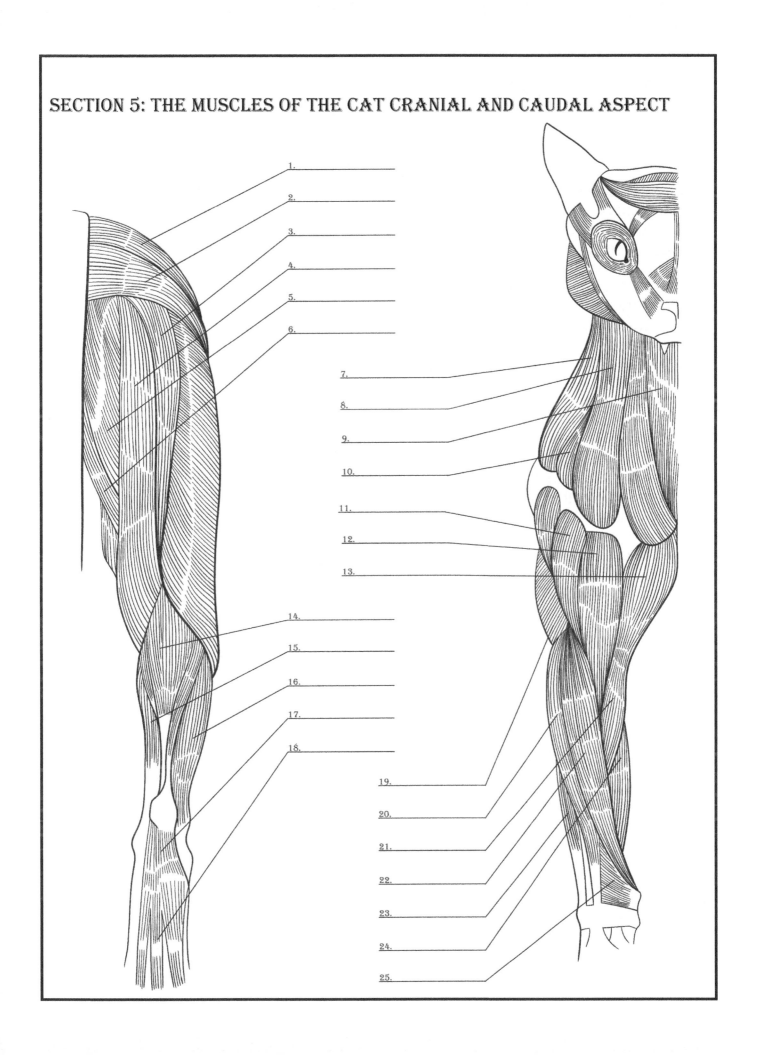

1.
2.
3.
4.
5.
6.
7.
8.
9.
10.
11.
12.
13.
14.
15.
16.
17.
18.
19.
20.
21.
22.
23.
24.
25.

SECTION 5: THE MUSCLES OF THE CAT CRANIAL AND CAUDAL ASPECT

1. GLUTEUS SUPERFICIAL MUSCLE
2. CAUDOFEMORALIS MUSCLE
3. BICEPS FEMORIS MUSCLE
4. SEMITENDINOSUS MUSCLE
5. SEMIMEMBRANOSUS MUSCLE
6. GRACILIS MUSCLE
7. TRAPEZIUS MUSCLE
8. BRACHIOCEPHALICUS MUSCLE
9. STERNOHYOIDEUS MUSCLE
10. OMOTRANSVERSARIUS MUSCLE
11. DELTOIDEUS MUSCLE
12. CLEIDOBRACHIALIS MUSCLE
13. PECTORALES MUSCLE
14. GASTROCNEMICUS MUSCLE
15. FLEXORES DIGITORUM PROFUNDI MUSCLE
16. EXTENSOR DIGITORUM MUSCLE
17. FLEXOR DIGITORUM SUPERFICIALIS MUSCLE
18. INTEROSSEI PLANTARES MUSCLE
19. TRICEPS BRACHII MUSCLE
20. EXTENSOR DIGITORUM COMMUNIS MUSCLE
21. PRONATOR TERES MUSCLE
22. EXTENSOR CARPI RADIALIS & BRACHIORADIALIS MUSCLE
23. EXTENSOR DIGITORUM LATERALIS MUSCLE
24. FLEXOR CARPI RADIALIS MUSCLE
25. ABDUCTOR DIGITI IST MUSCLE

SECTION 6: THE MUSCLES OF THE CAT VENTRAL ASPECT

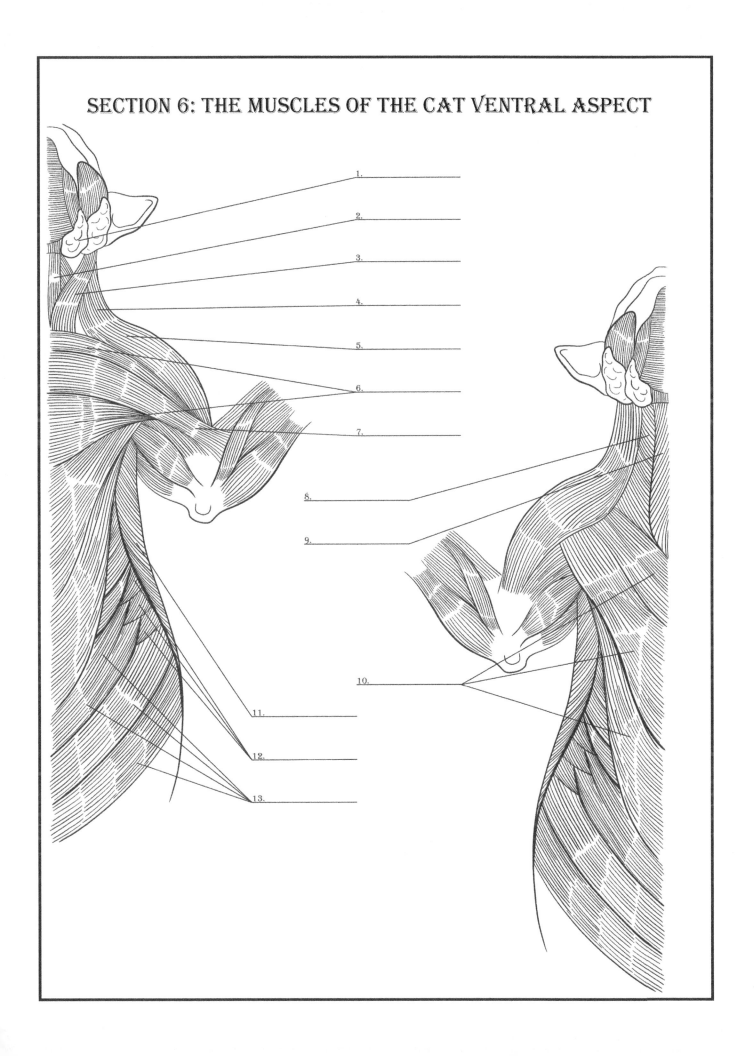

1. _____

2. _____

3. _____

4. _____

5. _____

6. _____

7. _____

8. _____

9. _____

10. _____

11. _____

12. _____

13. _____

SECTION 6: THE MUSCLES OF THE CAT VENTRAL ASPECT

1. MANDIBULAR GLAND
2. STERNOHPYOIDEUS MUSCLE
3. STERNOCEPHALICUS MUSCLE
4. CLEIDOCEPHALICUS, PARS CERVICALIS MUSCLE
5. CLEIDOCEPHALICUS, PARS MASTOIDEA MUSCLE
6. PECTORALIS TRANSVERSUS MUSCLE
7. PECTORALIS DESCENDENS MUSCLE
8. LONGUS CAPITIS MUSCLE
9. LONGUS COLLI MUSCLE
10. PECTORALIS PROFUNDUS MUSCLE
11. LATISSIMUS DORSI MUSCLE
12. SERRATUS VENTRALIS MUSCLE
13. OBLIQUUS EXTERNES ABDOMENS MUSCLE

SECTION 7: THE MUSCLES OF THE CAT DORSAL ASPECT

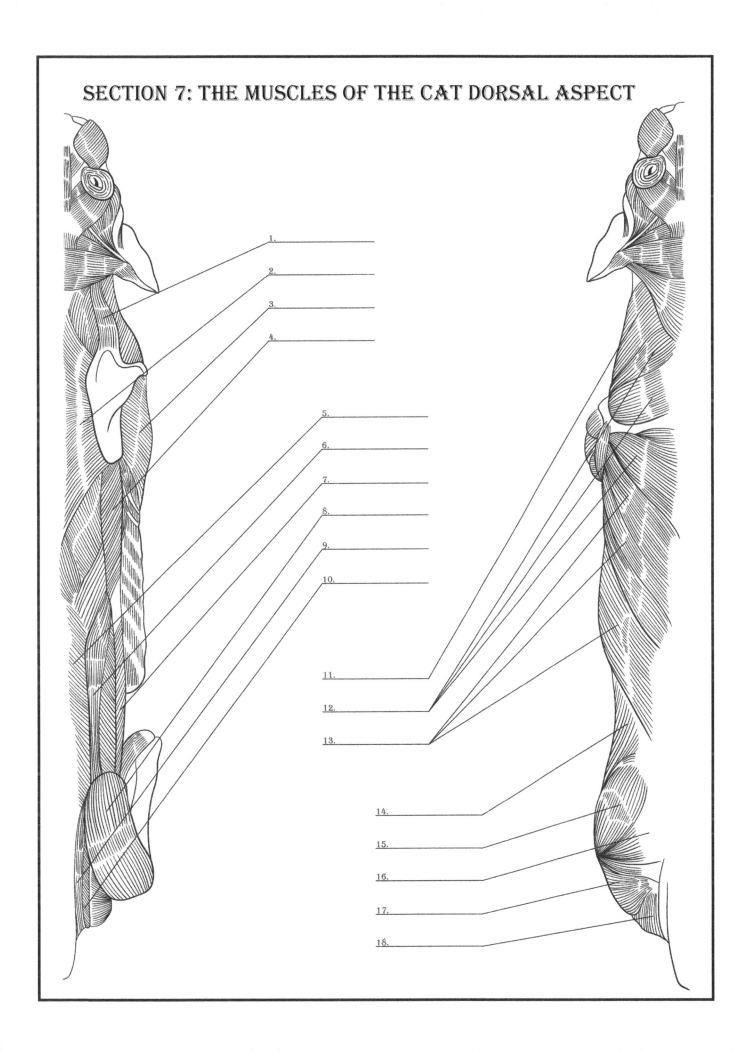

1.

2.

3.

4.

5.

6.

7.

8.

9.

10.

11.

12.

13.

14.

15.

16.

17.

18.

SECTION 7: THE MUSCLES OF THE CAT DORSAL ASPECT

1. RHOMBOIDEUS CAPITAIS MUSCLE
2. RHOMBOIDEUS THORACIS MUSCLE
3. SERRATUS VENTRALIS MUSCLE
4. LONGISSIMUS THORACIS MUSCLE
5. TRANSVERSOSPINALIS MUSCLE
6. LONGISSIMUS LUMBORUM MUSCLE
7. ILIOCOSTALIS LUMBORUM MUSCLE
8. GLUTEUS MEDIUS MUSCLE
9. SACROCAUDALIS DORSALIS MEDIALIS MUSCLE
10. SACROCAUDALIS DORSALIS LATERALIS MUSCLE
11. BRACHIOCEPUHALICUS MUSCLE
12. TRAPEZIUS MUSCLE
13. LATISSIMUS DORSI MUSCLE
14. OBLIQUUS EXTERNUS ABDOMINIS MUSCLE
15. GLUTEUS MEDIUS MUSCLE
16. GLUTEUS SUPERFICIALIS MUSCLE
17. BICEPS FEMORIS MUSCLE
18. SEMITENDINOSUS MUSCLE

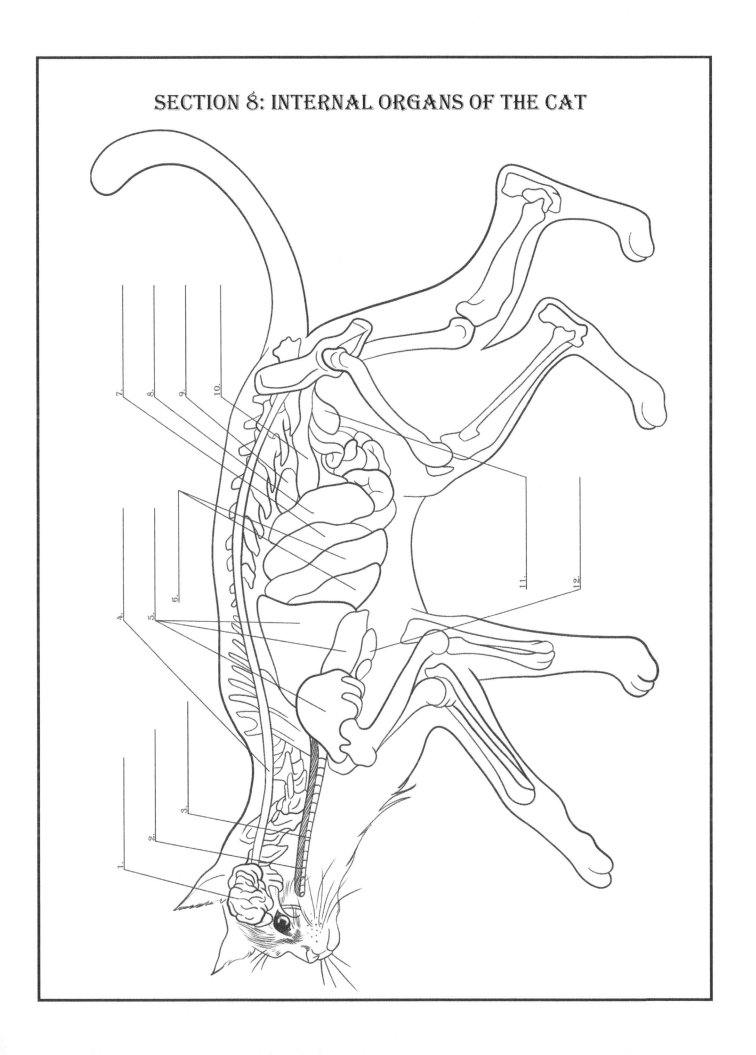

1.
2.
3.
4.
5.
6.
7.
8.
9.
10.
11.
12.

SECTION 8: INTERNAL ORGANS OF THE CAT

1. BRAIN
2. ESOPHAGUS
3. TRACHEA
4. SPINAL CORD
5. LUNGS
6. LIVER
7. STOMACH
8. SPLEEN
9. KIDNEY
10. COLON
11. BLADDER
12. HEART

SECTION 9: BLOOD VESSELS OF THE CAT

SECTION 9: BLOOD VESSELS OF THE CAT

1. CRANIAL VENA CAVA
2. HEART
3. AORTA
4. CAUDAL VENA CAVA
5. FEMORAL ARTERY
6. SAPHENOUS VEIN
7. SPLEEN
8. PORTAL VEINS
9. JUGULAR VEIN
10. CAROTID ARTERY
11. CEPHALIC VEIN
12. BRACHIAL ARTERY

SECTION 10: NERVES OF THE CAT

SECTION 10: NERVES OF THE CAT

1. CEREBRUM
2. CEREBELLUM
3. MEDULLA OBLONGATA
4. SPINAL CORD
5. THORACIC SPINAL
6. SCIATIC NERVE
7. FEMORAL NERVE
8. CERVICAL NERVE
9. RADIAL NERVE
10. THORACIC NERVE

SECTION 11: LUNGS OF THE CAT

1. _____

2. _____

3. _____

4. _____

5. _____

6. _____

7. _____

8. _____

9. _____

SECTION 11: RESPIRATORY SYSTEM OF THE CAT

1. RIGHT CRANIAL LOBE
2. LEFT CRANIAL LOBE
3. TRACHEA
4. LOBAR BRONCHUS
5. PRINCIPAL BRONCHUS
6. RIGHT MIDDLE LOBE
7. LEFT CAUDAL LOBE
8. RIGHT CAUDAL LOBE
9. ACCESSORY LOBE

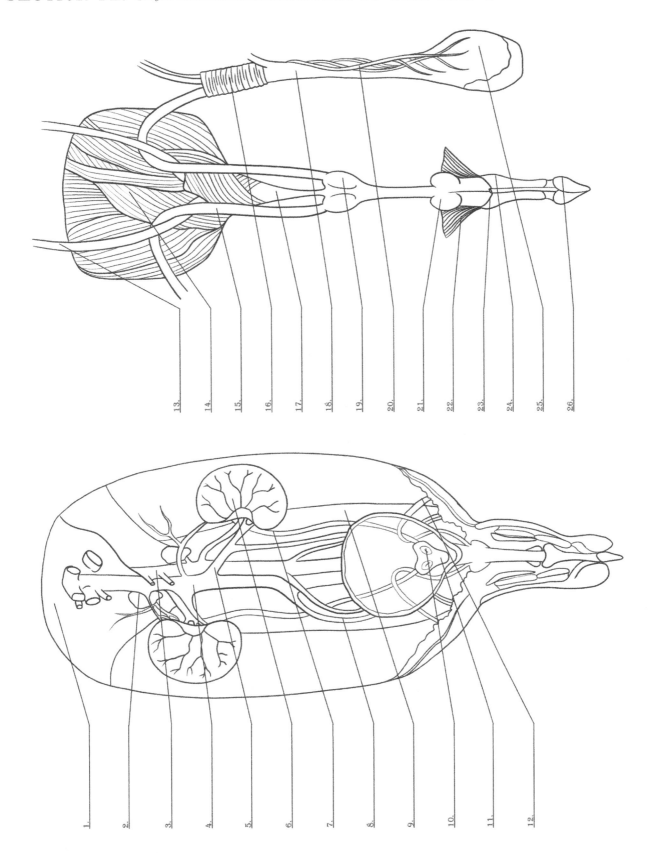

13.
14.
15.
16.
17.
18.
19.
20.
21.
22.
23.
24.
25.
26.

1.
2.
3.
4.
5.
6.
7.
8.
9.
10.
11.
12.

SECTION 12: UROGENITAL SYSTEM OF THE CAT 1

1. DIAPHRAGM
2. ADRENAL GLAND
3. ABDOMINAL AORTA
4. CAUDAL VENA CAVA
5. RENAL AORTA AND VEIN
6. KIDNEY
7. URETER
8. TESTICULAR AORTA AND VEIN
9. PSOAS MAJOR MUSCLE
10. ORIFICE OF URETER
11. VESICULAR TRIGONE
12. DUCTUS DEFERENS
13. URETER
14. URINARY BLADDER
15. DUCTUS DEFERENS
16. INGUINAL CANAL
17. NECK OF BLADDER
18. SPERMATIC CORD
19. PROSTATE GLAND
20. CREMASTER MUSCLE
21. BULBOURETHAL GLAND
22. ISCHIOCARVERNOSUS MUSCLE
23. BULBOSPONGIOSUS MUSCLE
24. BODY OF PENIS
25. TESTIS
26. GLANS PENIS

SECTION 13: UROGENITAL SYSTEM OF THE CAT 2

1.

2.

3.

4.

5.

6.

7.

8.

9.

10.

11.

12.

13.

14.

15.

16.

17.

18.

19.

20.

21.

22.

23.

24.

25.

26.

27.

28.

SECTION 13: UROGENITAL SYSTEM OF THE CAT 2

1. PAPILLA
2. KOSTIUM PAPILLARE
3. PAPILLARY DUCT
4. AMINIONIC MEMBRANE
5. FETUS
6. ZONARY PLACENTA
7. ALLANTONIC MEMBRANE
8. UMBILICAL CORD
9. CHORIONIC MEMBRANE
10. LATERAL THORACIC VEIN AND ARTERY
11. CAUDAL THORACIC MAMMA
12. CRANIAL ABDOMINAL MAMMA
13. CRANIAL SUPERFICIAL EPIGASTRIC VEIN AND ARTERY
14. CAUDAL ABDOMINAL MAMMA
15. INGUINAL MAMMA
16. CAUDAL SUPERFICIAL EPIGASTRIC VEIN AND AORTA
17. KIDNEY
18. URETER
19. SUSPENSORY LIGAMENT
20. OVARY
21. UTERINE HORN
22. BROAD LIGAMENT
23. RECTUM
24. URINARY BLADDER
25. VAGINA
26. PELVIC SYMPHIS
27. VESTIBULE
28. VULVA

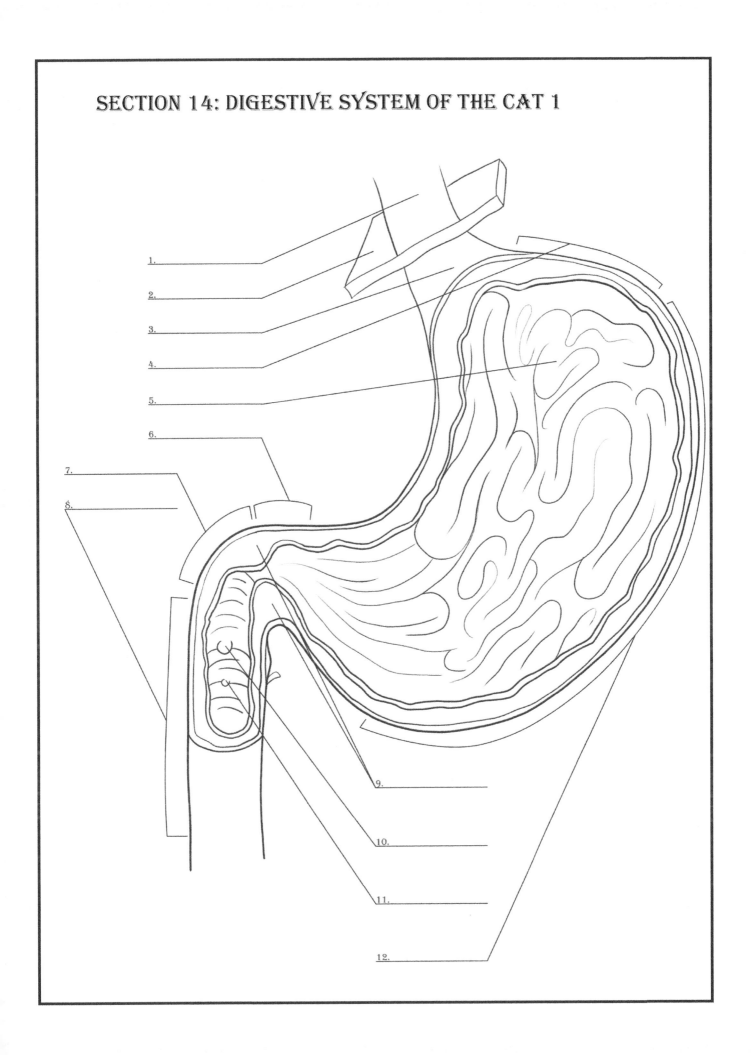

1.

2.

3.

4.

5.

6.

7.

8.

9.

10.

11.

12.

SECTION 14: DIGESTIVE SYSTEM OF THE CAT 1

1. ESOPHAGUS
2. DIAPHRAGM
3. CARDIA
4. FUNDUS
5. GASTRIC FOLDS
6. PYLORIC ANTRUM
7. PYLORIC CANAL
8. DESCENDING DUODENUM
9. PYLORIC SPINCTER
10. MAJOR DUODENAL PAPILLA
11. MINOR DUODENAL PAPILLA
12. BODY OF STOMACH

SECTION 15: DIGESTIVE SYSTEM OF THE CAT 2

1.
2.
3.
4.
5.
6.
7.
8.
9.
10.
11.
12.
13.
14.
15.
16.
17.
18.
19.
20.
21.
22.

SECTION 15: DIGESTIVE SYSTEM OF THE CAT 2

1. CAUDAL VENA CAVA
2. PORTAL VEIN
3. HEPATIC ARTERY
4. GALL BLADDER
5. LEFT LATERAL LOBE
6. PAPILLARY PROCESS OF CAUDATE LOBE
7. CAUDATE PROCESS OF CAUDATE LOBE
8. RIGHT LATERAL LOBE
9. RIGHT MEDIAL LOBE
10. QUADRATE LOBE
11. CAUDAL VENA CAVA
12. HEPATIC VEIN
13. CORONARY LIGAMENT
14. LEFT TRIANGULAR LIGAMENT
15. RIGHT TRIANGULAR LIGAMENT
16. RIGHT LATERAL LOBE
17. CAUDATE PROCESS
18. RIGHT MEDIAL LOBE
19. ROUND LIGAMENT OF LIVER
20. GALL BLADDER
21. LEFT MEDIAL LOBE
22. LEFT LATERAL LOBE

SECTION 16: THE SKULL OF THE CAT LATERAL ASPECT

SECTION 16: THE SKULL OF THE CAT LATERAL ASPECT

1. PREMAXILLA
2. NASAL BONE
3. MAXILLA
4. LACRIMAL BONE
5. ETHMOID
6. PALATINE BONE
7. ORBIT
8. FRONTAL BONE
9. PARIETAL BONE
10. TEMPORAL BONE
11. SAGITTAL CREST
12. EXTERNAL ACOUSTIC MEATUS
13. TYMPANIC BULLA
14. NUCHAL BREAST
15. OCCIPITAL BONE
16. OCCIPITAL CONDYLE
17. ZYGOMATIC BONE
18. TEMPOROMANDIBULAR JOINT
19. ANGULAR PROCESS OF MANDIBLE
20. MANDIBLE
21. UPPER FOURTH PREMOLAR
22. INFRAORBITAL FORAMEN
23. CARNASSIAL TOOTH
24. DENTARY
25. CANINE TOOTH
26. INCISOR TOOTH

SECTION 17: INSIDE THE SKULL OF THE CAT

SECTION 17: INSIDE THE SKULL OF THE CAT

1. PREMAXILLA
2. TURBINALS
3. NASAL
4. ETHMOID
5. FRONTAL
6. CRIBIFORM PLATE
7. PARIETAL
8. TENTORIUM
9. TORSUM SELLAE
10. HIATUS FACIALIS
11. SUBARCUATE FOSSA
12. CEREBELLAR FOSSA
13. INTERNAL AUDITORY MEATUS
14. ENDOLYMPHATIC FORAMEN
15. CONDYLAR FORAMEN
16. HOMULUS
17. SPHENOIDAL SINUS
18. PALATINE
19. MAXILLA

SECTION 18: THE SKULL OF THE CAT DORSAL ASPECT

1. _____

2. _____

3. _____

4. _____

5. _____

6. _____

7. _____

8. _____

9. _____

SECTION 18: THE SKULL OF THE CAT DORSAL ASPECT

1. SAGITTAL CREST
2. LAMBDOIDAL RIDGE
3. PARIETAL
4. FRONTAL
5. POSTORBITAL PROCESS
6. MANDIBLE
7. MAXILLA
8. PREMAXILLA
9. CANINE TOOTH

SECTION 19: THE SKULL OF THE CAT VENTRAL ASPECT

1. _____

2. _____

3. _____

4. _____

5. _____

6. _____

7. _____

8. _____

9. _____

10. _____

11. _____

12. _____

13. _____

14. _____

15. _____

16. _____

17. _____

18. _____

19. _____

20. _____

21. _____

SECTION 19: THE SKULL OF THE CAT VENTRAL ASPECT

1. INCISIVE FORAMEN
2. INCISOR TOOTH
3. PREMAXILLA
4. INFRAORBITAL FORAMEN
5. MOLAR TOOTH
6. MAXILLA
7. ORBITOSPHLENOID
8. PRESPHENOID
9. ALISPHLENOID
10. HYPOPHYSEAL FENESTRA
11. FORAMEN OVALE
12. ZYGOMATIC PROCESS
13. GLENOID FOSSA
14. POSTGLENOID PROCESS
15. TYMPANIC
16. STYLOMASTOID FORAMEN
17. MASTOID PROCESS
18. ENTOTYMPANIC
19. EXOCCIPITAL PROCESS
20. HYPOGLOSSAL FORAMEN
21. FORAMEN MAGNUM

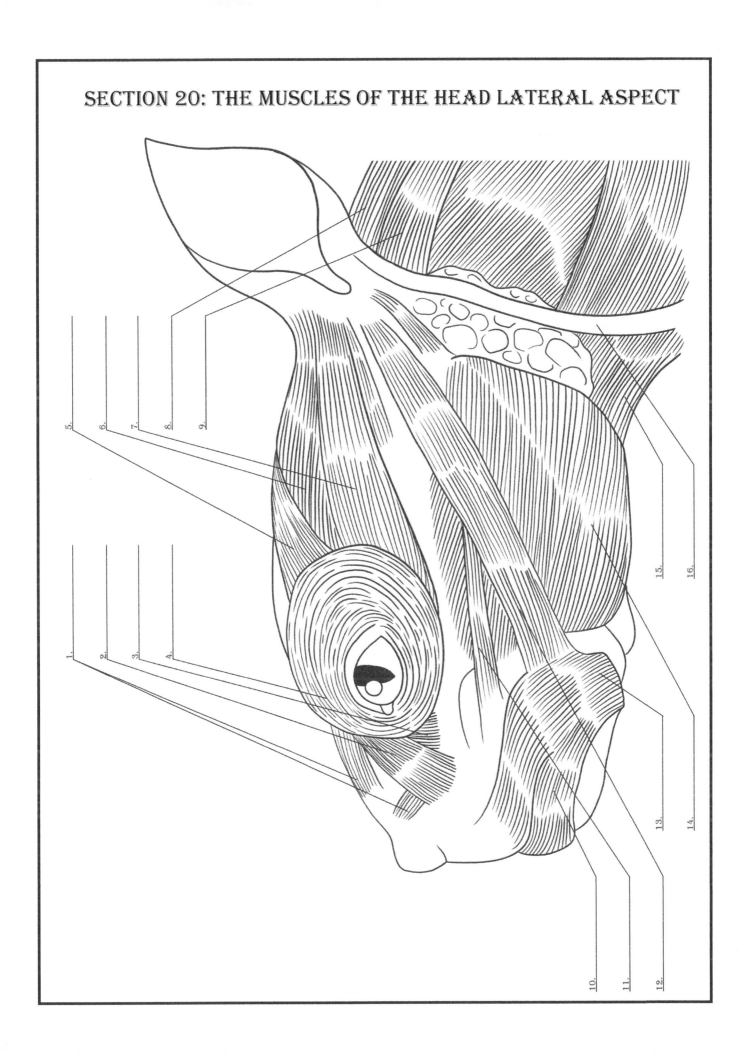

SECTION 20: THE MUSCLES OF THE HEAD LATERAL ASPECT

1. DORSALIS & LATERALIS NASI MUSCLES
2. LEVATOR NASOLABIALIS MUSCLE
3. MALARIS MUSCLE
4. ORBICULARIS OCULI MUSCLE
5. LEVATOR PALPEERDE SUPERIORIS MUSCLE
6. FRONTOSCUTULARIS MUSCLE
7. TEMPORALIS MUSCLE
8. CERVICOAURICULARIS PROFUNDUS MUSCLE
9. CERVICOAURICULARIS SUPERFICIALIS MUSCLE
10. ORBICULARIS ORIS MUSCLE
11. DEPRESSOR LABII MAXILLARIS MUSCLE
12. ZYGOMATICUS MUSCLE
13. DEPRESSOR LABII MANDIBULARIS MUSCLE
14. MASSETER MUSCLE
15. STERNOHPYOIDEUS MUSCLE
16. PARTOIDEOAURICULARIS MUSCLE

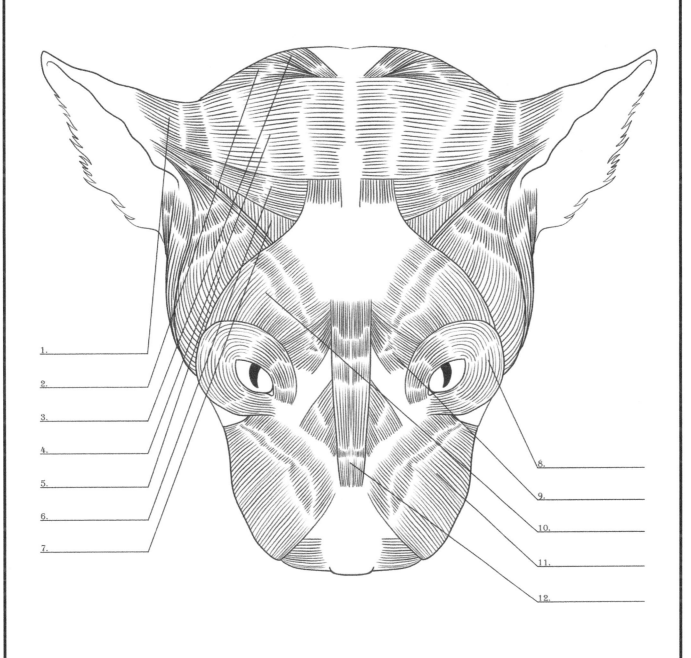

1.

2.

3.

4.

5.

6.

7.

8.

9.

10.

11.

12.

SECTION 21: THE MUSCLES OF THE HEAD DORSAL ASPECT

1. SCUTULOAURICULARIS PROFUNDUS MUSCLE
2. CERVICOAURICULARIS SUPERFICIALIS MUSCLE
3. CERVICOAURICULARIS PROFUNDUS MUSCLE
4. INTERSCUTULARIS MUSCLE
5. ZYGOMATICOAURICULARIS MUSCLE
6. PARIETOSCUTULARIS MUSCLE
7. TEMPORALIS MUSCLE
8. ORBICULARIS OCULI MUSCLE
9. LEVATOR OF THE MEDIAL EYE ANGLE
10. LEVATOR PALPEBRAE SUPERIORIS MUSCLE
11. LEVATOR NASOLABIALIS MUSCLE
12. DORSALIS NASI MUSCLE

SECTION 22: THE BRAIN OF THE CAT

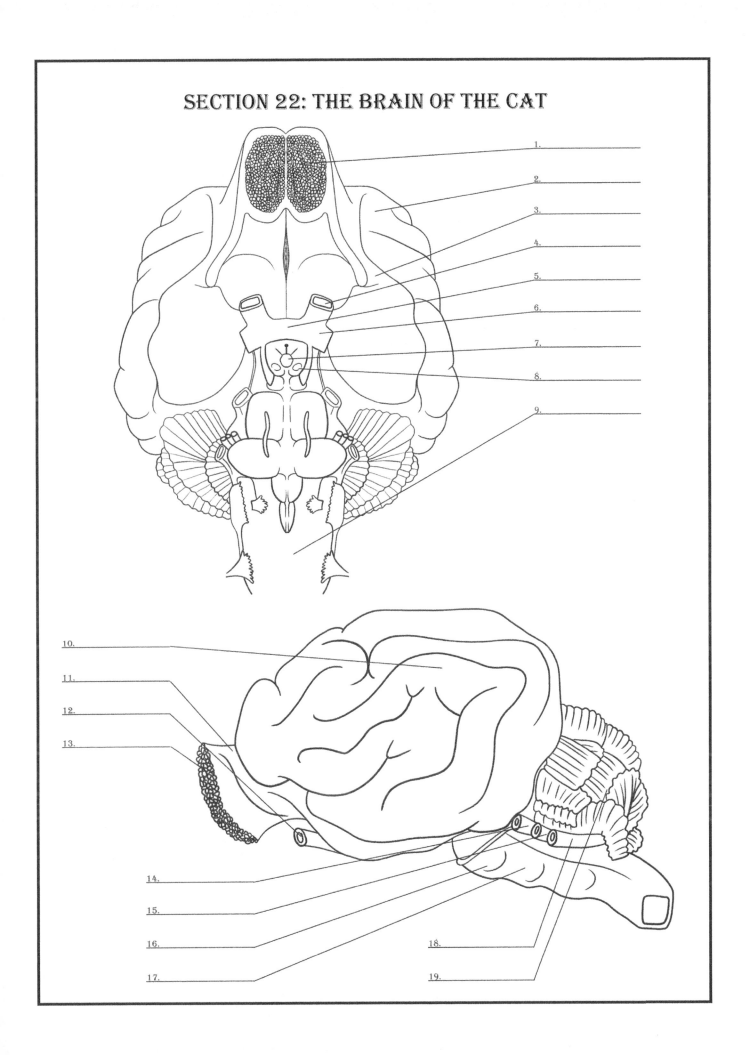

1.

2.

3.

4.

5.

6.

7.

8.

9.

10.

11.

12.

13.

14.

15.

16.

17.

18.

19.

SECTION 22: THE BRAIN OF THE CAT

1. OLFACTORY BULB
2. CEREBRAL HEMISPHERE
3. OLFACTORY TRACT
4. OPTIC NERVE
5. OPTIC CHIASM
6. OPTIC TRACT
7. HYPOPHYSIS
8. MAMMILLARY BODIES
9. MEDULLA
10. CEREBRAL HEMISPHERE
11. OLFACTORY TRACT
12. OPTIC NERVE
13. OLFACTORY BULB
14. TRIGEMINAL NERVE
15. FACIAL NERVE
16. PONS
17. VESTIBULOCOCHLEAR NERVE
18. CEREBELLAR HEMISPHERE

SECTION 23: THE EYE OF THE CAT

SECTION 23: THE EYE OF THE CAT

1. OPTIC NERVE
2. OPTIC DISC
3. CHOROID
4. TAPETUM LUCIDUM
5. RETINA
6. VITREOUS HUMOR
7. ARTERY
8. CILIARY BODY
9. POSTERIOR CHAMBER
10. ANTERIOR CHAMBER
11. PUPIL
12. LENS
13. IRIS

SECTION 24: THE EAR OF THE CAT

1. _____

2. _____

3. _____

4. _____

5. _____

6. _____

7. _____

8. _____

9. _____

10. _____

11. _____

12. _____

13. _____

14. _____

15. _____

16. _____

17. _____

18. _____

19. _____

20. _____

21. _____

22. _____

23. _____

24. _____

25. _____

26. _____

SECTION 24: THE EAR OF THE CAT

1. SCAPHA
2. CONCHA
3. EXTERNAL EAR CANAL VERTICAL PART
4. TEMPORALIS MUSCLE
5. SKULL
6. EXTERNAL EAR CANAL VERTICAL PART
7. OSSEOUS SEMICIRCULAR CANALS
8. INCUS
9. MALLEUS
10. EAR OSSICLE
11. PETROUS TEMPORAL BONE
12. OSSEOUS VESTIBULE
13. OSSEOUS COCHLEA
14. PETROUS TEMPORAL BONE
15. TYMPANIC MEMBRANE
16. AUDITORY TUBE
17. TYMPANIC BULLA
18. ANNULAR CARTILAGE
19. SHORT CRUS
20. INCUS
21. HEAD
22. LONG CRUS
23. MALLEUS
24. STAPES
25. BASE
26. MANUBRIUM

SECTION 25: THE HEART OF THE CAT

1.
2.
3.
4.
5.
6.
7.
8.
9.
10.
11.
12.
13.

SECTION 25: THE HEART OF THE CAT

1. AORTIC ARCH
2. RIGHT ATRIUM
3. PULMONARY ARTERY
4. LEFT ATRIUM
5. RIGHT VENTRICLE
6. LEFT VENTRICLE
7. RIGHT VENTRICLE
8. PAPILLARY MUSCLE
9. CHORDA TENDINEA
10. VENTRICULAR SEPTUM
11. RIGHT VENTRICULAR FREE WALL
12. LEFT VENTRICLE
13. LEFT VENTRICULAR FREE WALL

SECTION 26: THORACIC LIMB

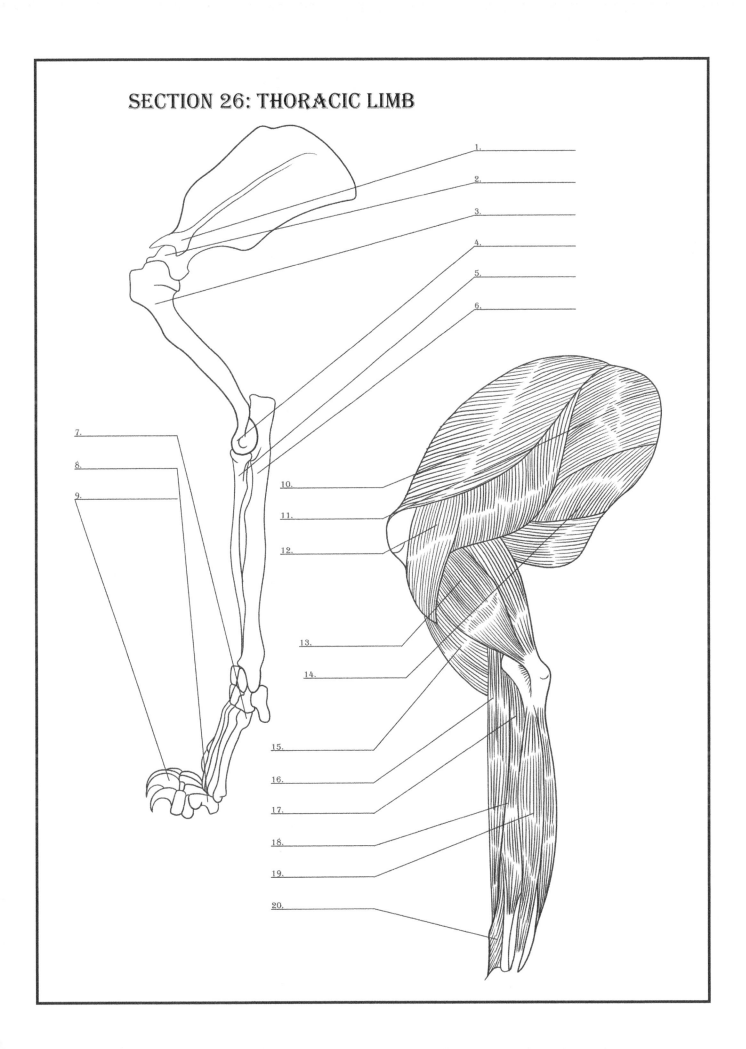

1.

2.

3.

4.

5.

6.

7.

8.

9.

10.

11.

12.

13.

14.

15.

16.

17.

18.

19.

20.

SECTION 26: THORACIC LIMB LATERAL ASPECT

1. PROCESS OF THE SHOULDER BLADE
2. SHOULDER JOINT
3. HUMERUS
4. ELBOW JOINT
5. RADIUS
6. ULNA
7. METACARPAL BONE
8. PHALANGEAL BONE
9. CLAW BONE
10. SUPRASPINATUS MUSCLE
11. INFRASPINATUSM MUSCLE
12. DELTOIDEUS MUSCLE
13. LATISSIMUS DORSI MUSCLE
14. TERES MAJOR MUSCLE
15. BICEPS BRACHII MUSCLE
16. BRACHIORADIALIS MUSCLE
17. EXTENSOR CARPI RADIALIS MUSCLE
18. EXTENSOR DIGITORUM COMMUNIS MUSCLE
19. EXTENSOR DIGITORUM LATERALIS MUSCLE
20. ABDUCTOR DIGITI IST MUSCLE

SECTION 27: PELVIC LIMB

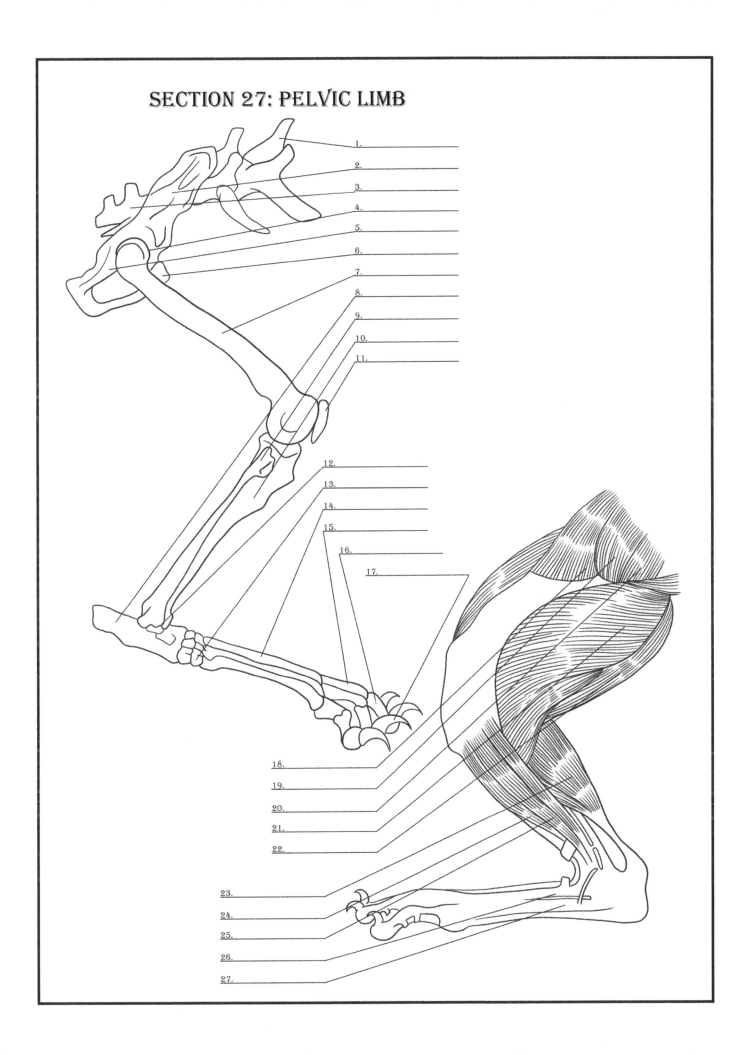

1.
2.
3.
4.
5.
6.
7.
8.
9.
10.
11.
12.
13.
14.
15.
16.
17.
18.
19.
20.
21.
22.
23.
24.
25.
26.
27.

SECTION 27: PELVIC LIMB

1. LAST LUMBAR VERTEBRA
2. HIP BONE
3. SACRUM
4. HIP JOINT
5. ISCHIAL BONE
6. PUBIC BONE
7. FEMUR
8. CALCANEUS
9. FIBULA
10. TIBIA
11. PATELLA
12. DISTAL TIBIO-FIBULAR JOINT
13. TARSAL BONE
14. METATARSAL BONE
15. PROXIMAL PHALANGEAL BONE
16. MIDDLE PHALANGEAL BONE
17. CLAW BONE
18. TENSOR FASCIAE LATAE MUSCLE
19. GLUTEUS MEDIUS MUSCLE
20. GLUTEUS SUPERFICIALIS MUSCLE
21. BICEPS FEMORIS MUSCLE
22. SEMITENDINOSUS MUSCLE
23. TRICEPS SURAE MUSCLE
24. TIBIALIS CRANIALIS MUSCLE
25. PERONEUS LONGUS MUSCLE
26. EXTENSOR DIGITORUM LONGUS MUSCLE
27. EXTENSOR DIGITORUM LATERALIS MUSCLE

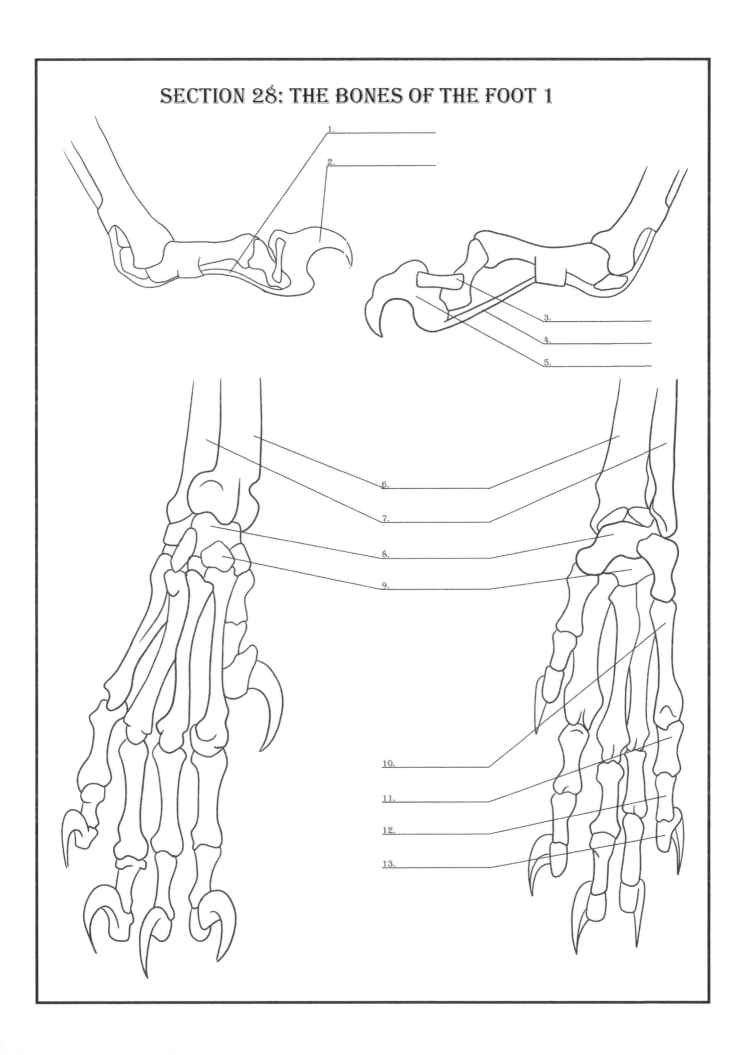

1.
2.
3.
4.
5.
6.
7.
8.
9.
10.
11.
12.
13.

SECTION 28: THE BONES OF THE FOOT 1

1. RELAXED TENDON
2. RETRACTED CLAW
3. LIGAMENT
4. TIGHTENED TENDON
5. EXTENDED CLAW
6. RADIUS
7. ULNA
8. PROXIMAL ROW OF CARPAL BONES
9. DISTAL ROW OF CARPAL BONES
10. METACARPAL BONE
11. PROXIMAL PHALANX
12. MIDDLE PHALANX
13. DISTAL PHALANX

SECTION 29: THE BONES OF THE FOOT 2

1. _____

2. _____

3. _____

4. _____

5. _____

6. _____

7. _____

8. _____

9. _____

10. _____

11. _____

12. _____

13. _____

14. _____

15. _____

16. _____

17. _____

18. _____

19. _____

20. _____

21. _____

22. _____

23. _____

24. _____

SECTION 29: THE BONES OF THE FOOT 2

1. EXTENSOR CARPI RADIALIS MUSCLE
2. COMMON DIGITAL EXTENSOR MUSCLE
3. LATERAL DIGITAL EXTENSOR MUSCLE
4. EXTENSOR CARPI ULNAS MUSCLE
5. FLEXOR CARPI ULNARIS
6. ABDUCTOR POLLICIS LINGUS MUSCLE
7. EXTENSOR RETINACULUM
8. TENDON OF MUSCLES EXTENSOR DIGITI
9. CLAW COVERING UNGICULAR PROCESS
10. DIGITAL EXTENSOR MUSCLE
11. SKIN OF CLAW SHEATH
12. COMBINED EXTENSOR TENDOUS
13. EXTENSOR PROCESS
14. UNGUICULAR CREST
15. UNGUICULAR PROCESS
16. CLAW
17. MIDDLE PHALANX
18. TENDON OF DEEP DIGITAL FLEXOR MUSCLE
19. FLEXOR TUBERCLE
20. DIGITAL PAD
21. TAUT ELASTIC LIGAMENT
22. TAUT DIGITAL FLEXOR TENDON
23. EXTENSOR PROCESS
24. PIVOT POINT

Made in the USA
Monee, IL
22 August 2022

12219604R00037